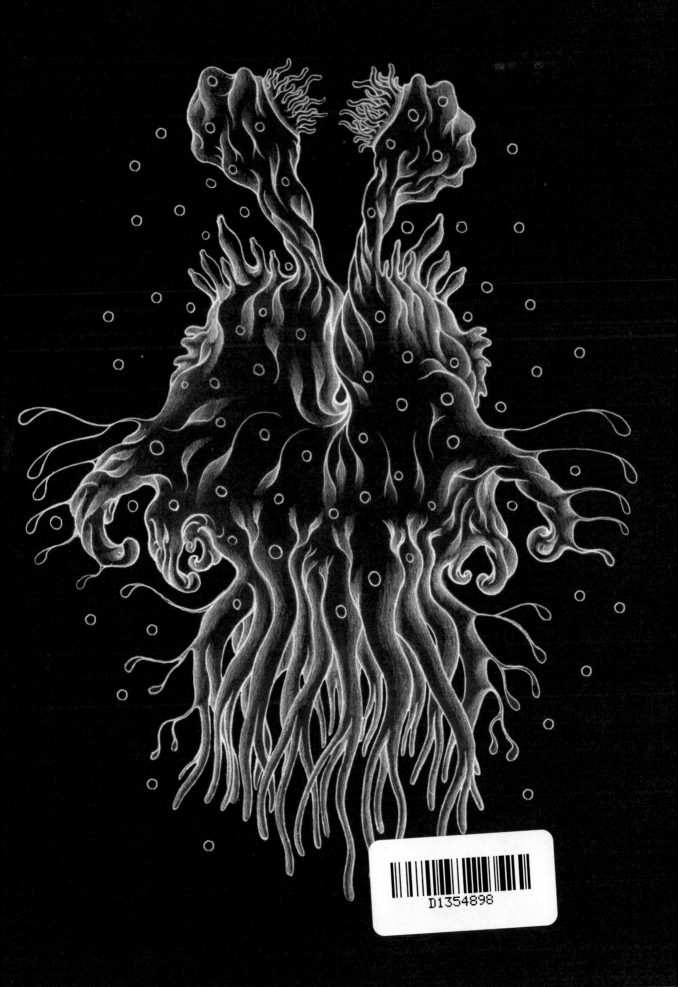

A JOURNEY IN THE PHANTASMAGORICAL GARDEN OF APPARITIO ALBINUS

Claudio Andrés Salvador Francisco
Romo Torres

Translation by David Haughton

GINGKO PRESS

My name is Apparitio Albinus and I live in a garden filled with ghosts...

The Fountain.

It is shaped like a chalice and its waters possess miraculous properties. With my own eyes I have seen how immersion in this liquid literally rejuvenates those who swim in it. The swimmers... they are actually my neighbours. Having discovered a hole in the boundary fence which surrounds my garden, they sneak in on a regular basis and dive into my fountain to recover their – evidently wasted – youth.
I find it hard to resist the pleasure of watching the effects of the inverted flow of time on my intruders' skins. On top of this, from time to time the enormous eye of a jealous god appears in the sky and transforms them into superb mutants of a basically vegetal nature. I observe them fleeing, terrified, metamorphosed into strange flowers, wild varieties of pineapple and Cucumis.

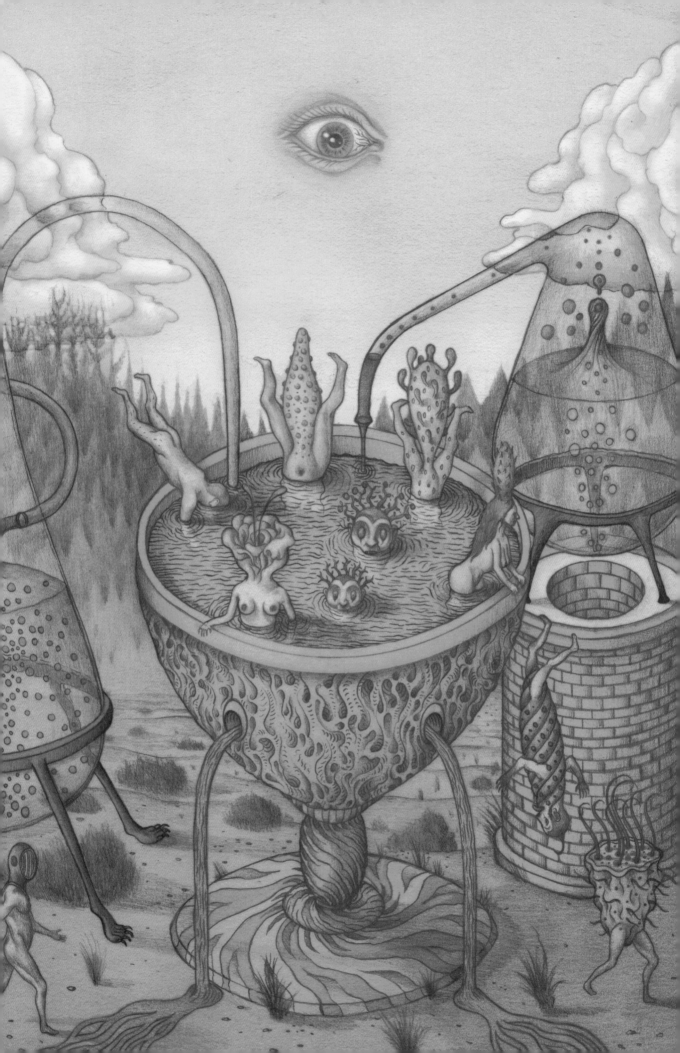

The Giant Automaton.

He first arrived here moving extremely slowly, since his source of energy appeared to be on the verge of exhaustion. One evening, shortly before falling asleep, he told me that along with other automatons of the same kind, he once used to fight in the army of Suleiman the Magnificent, in the ranks of the elite Regiment of the Janissaries. In many wars, his four scimitars had tasted the dark blood of exterminated armies and valiant enemies. He had fought in countless epic battles, including the conquest of fortified Rhodes, of white Belgrade and proud Baghdad. In the midst of the fray he sang the praises of Allah, the One and the Merciful, as thousands of arrows stung his gigantic armoured body like innocuous wasps. He had been happy, he told me, and yet... as time passed he found it ever more difficult to bear the violence, above all the slaughter caused by firearms, which was responsible for even greater carnage and for the senseless accidental butchering of innocent lives. So he had left. He had abandoned military life and its ceaseless massacres. However, he had been unable to obtain official permission from the Sultan, and therefore had become an outcast, a deserter.
So he had wandered through the world until, by pure chance, one day he heard about this garden, where he had finally found peace. Now his body is home to flocks of birds, which nest and sing and lay their eggs there. Every sunset he sings suras from the Koran... but only those which praise the infinite mercy of God.

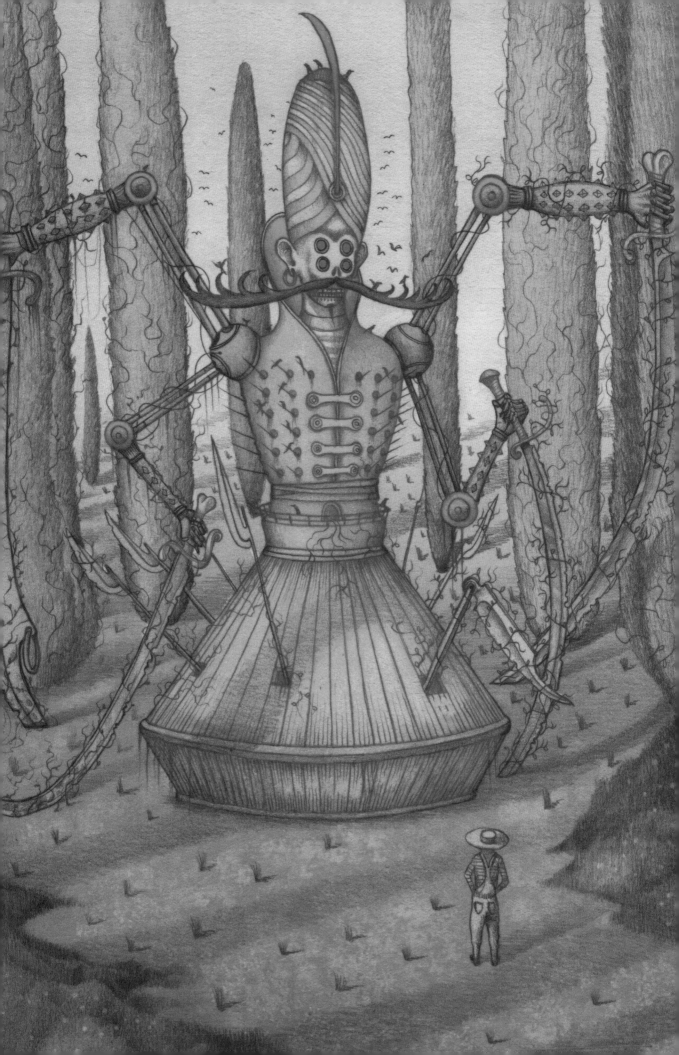

The Human Dress is forged Iron,
The Human Form a fiery Forge,
The Human Face a Furnace seal'd,
The Human Heart its hungry Gorge.
(W. Blake)

The Deeply-rooted Ovens.

Their outlines on the horizon are like crusts over an open wound which refuses to heal. From the distance I can make out the barred doors, resembling hungry mouths. Someone or something was incinerated once in there, a long, long time ago... an entity of such vast dimensions that its smoke still stains the sky today.
In dreams I explore (i.e. imagine) their inner structure. I descend into the bowels of the earth on an unending spiral stairway, in whose confining walls numerous burial niches have been hollowed out. Finally, at a great depth, I find an empty one. My name is written above it, so I enter and lie down. The last thing I see before falling asleep is the tenuous light of the sun filtering down from what has become an insurmountable height.

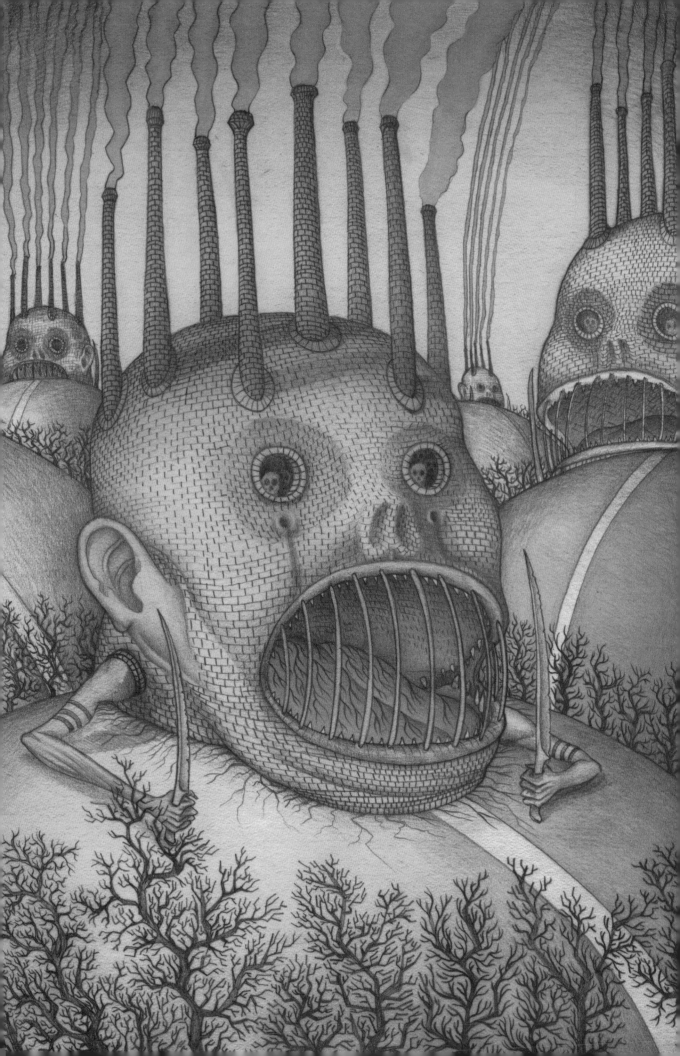

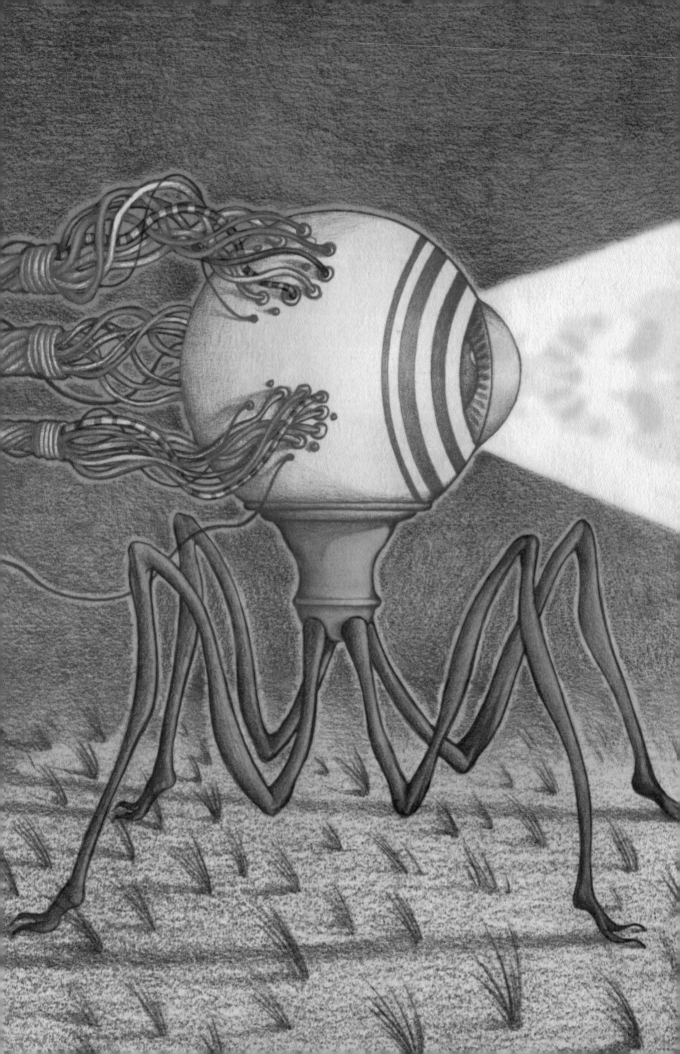

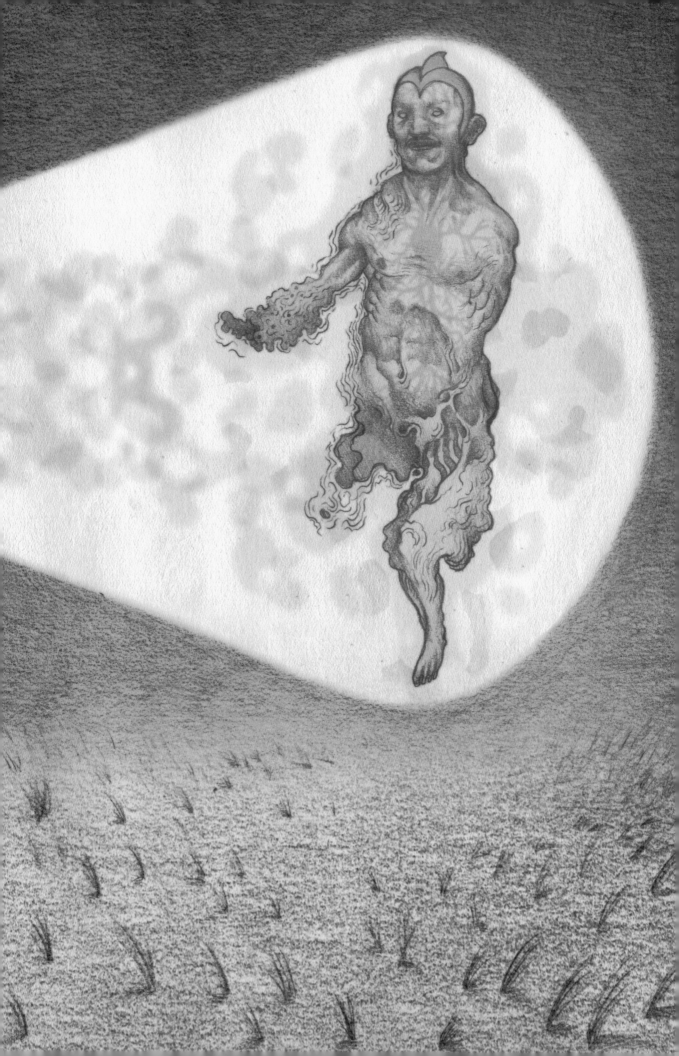

The Phantasmagorical Machine.

Years ago, together with my friend Lazzaro Morel, I built Faustine, a device capable of recording the image of a person and then projecting it. Unfortunately, exactly as was feared when photography was first developed, our machine really did absorb the soul of the person portrayed. We didn't realise this at first, and we ended up — Lazzaro more than me — paying the price for it. Between tests and try-outs, we recorded a dozen or so subjects, including Lazzaro, who had courageously offered to be the first experimental volunteer. But a few days later, all the subjects appeared to have been drained of any trace of vitality, willpower or initiative. Evidently, the procedure had not been so simple and innocuous, because the machine consumed people's vital forces, transforming them progressively into ghosts and reducing their flesh to ectoplasmic material. Imagine my shock when the bodies of those individuals underwent this irreversible process of decomposition which led to their deaths!

Nowadays I only turn Faustine on in order to interrogate the ghosts — and particularly that of Lazzaro, whose powers of observation I have always envied — about their experiences in the new life they lead in limbo.

The Mechanical Arachnids.

The lawns of my garden are criss-crossed by a race of tiny humanoid creatures.
A lineage of less-than-Lilliputians, singular myrmidons which periodically migrate across my land... to their eyes an entire universe of inconceivably vast expansion. According to their creation myths, they descend from the seeds of a pepper, the generative mother of the cosmos. Actually, to be more precise, they believe themselves descended from red peppers, while another people, dwelling further to the south — always this mania for creating divisions! — asserts their descent from green peppers: hence the age-old deep-seated hostility between these two peoples. Their founding myths, living perpetuations of far-off memories, narrate the milestone events in their history, such as the first time their founding father rode an earthworm. Over the centuries, the details of this epic feat were passed down from generation to generation, recounting every detail of the hero's acts as he tamed and guided the worms of the earth, like the Fremen in the desert planet of Arrakis, albeit on a much smaller scale.
The population became split into clans, and their intrinsic nomadism led to the construction of mobile city-states built on magnificent mechanical arachnids, on top of which they now travel, trade, hunt and dwell.

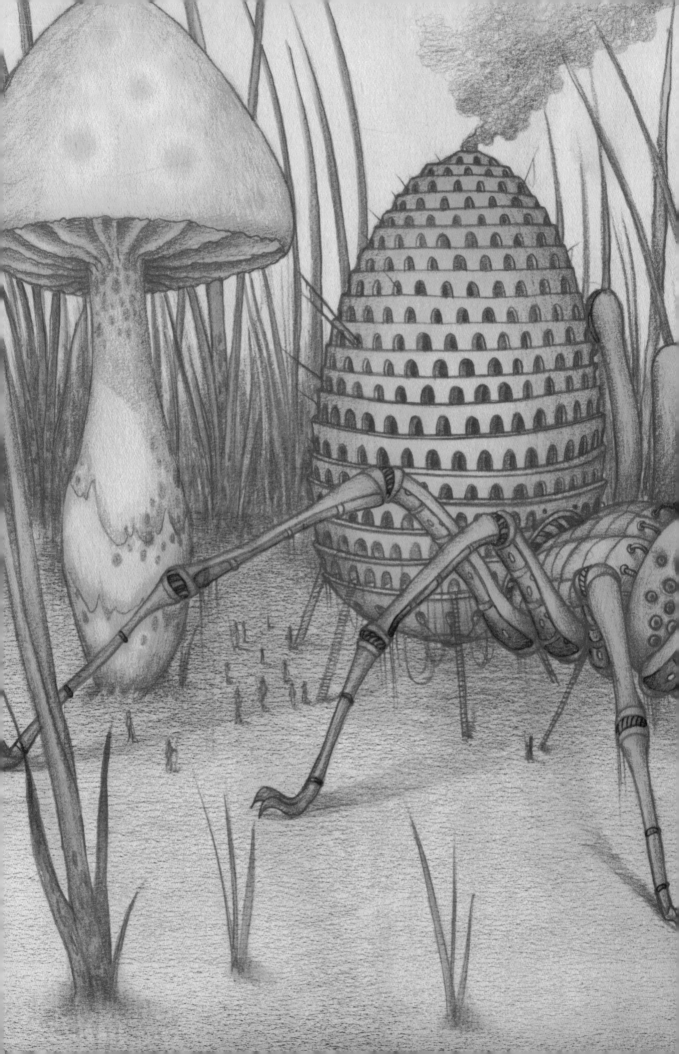

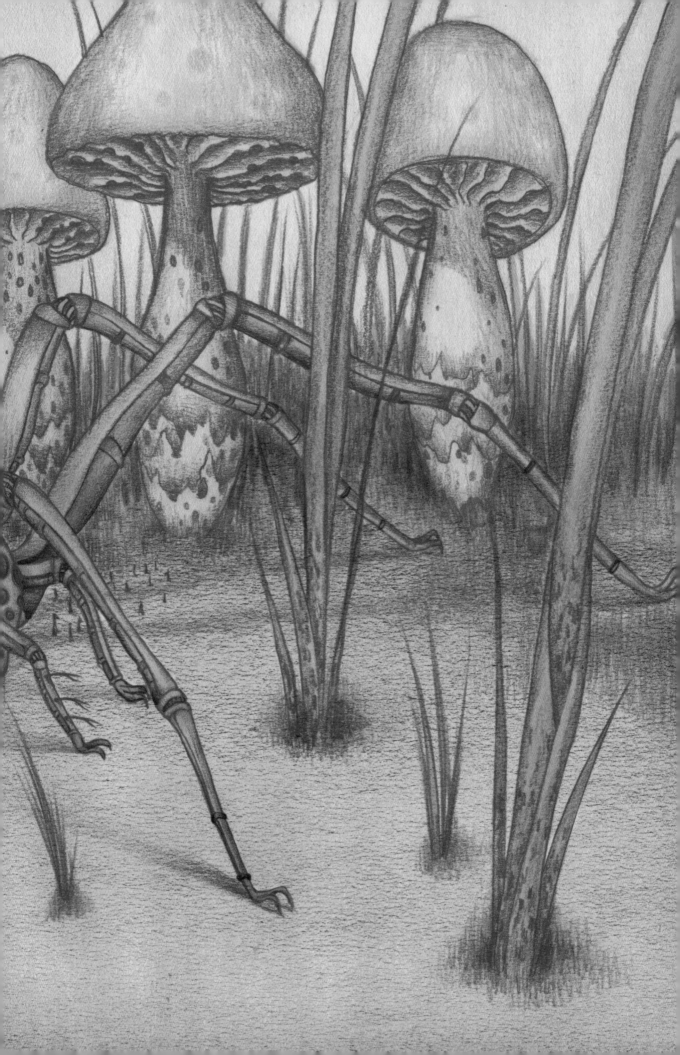

Flavia, the Gynoid Scribe.

I bought her in the Calle de Donceles in Mexico City, where she adorned the shop window of the antique bookseller Melquíades Herrera Becerril. In response to my insistent questions and curiosity, the man informed me that she had once been part of the treasure of the immensely powerful Tlatoani Moctezuma Xocoyotzin, to whom she had been offered as a gift by dignitaries from an ancient city situated on an island which has long since been swallowed up by the sea.

Beautiful automaton, lantern of knowledge, delight of princes, Flavia now passes her days writing the histories of the many kingdoms where she has lived.

Her first volumes deal with Thule, inhabited by blue Hyperboreans, and then she dealt with the underground kingdom of Agarthi and the legendary island of Aztlán, mother of dynasties and civilisations. After these came names in arcane and largely incomprehensible languages, echoing with primeval empires and long forgotten kingdoms.

From time to time, among her notes, I have found hints and clues to her improbable origins: it seems she was designed by an Arab mathematician who had dedicated his life to constructing a new humanity, strictly mechanical, in order to be definitively free from the then emerging monotheistic religions.

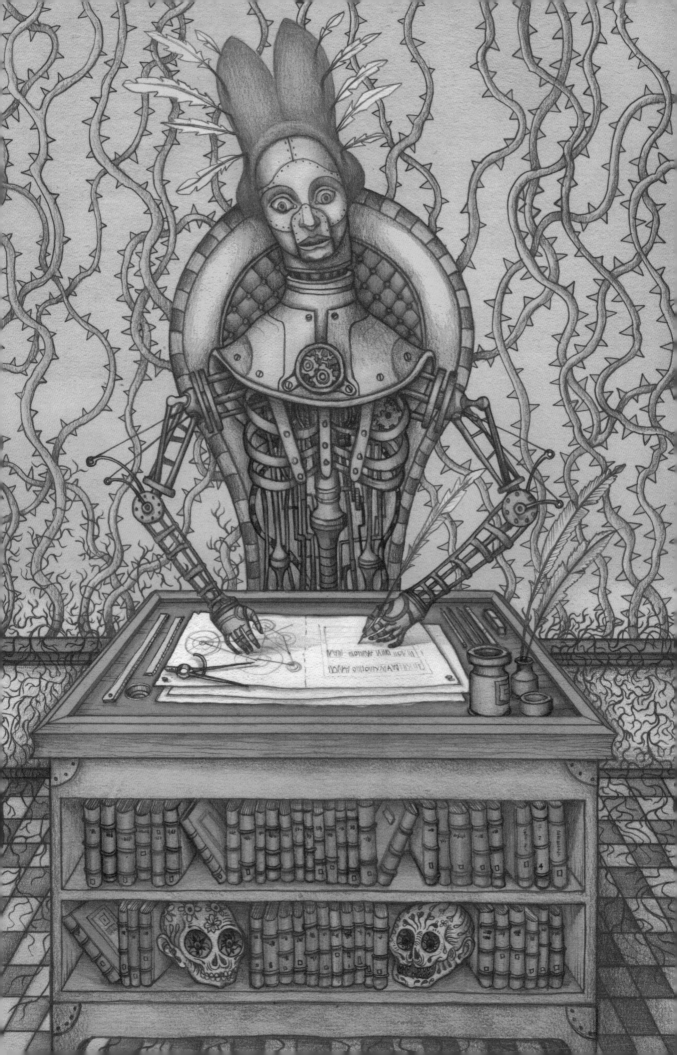

Woe to those who twist the axis of the universe,
Because the only fruits of their oblique achievement
Will be destruction and bereavement.
(Anonymous mechanist)

The Time Machine.

In my youth, I became interested in time travel, and I devoted all my energy to the construction of a chronoship.

After some years devoted to this project, I created a machine capable of taking me beyond the boundaries of past and future, to reveal to me the mysteries of matter and its eternal becoming, and show me what would become of me, my garden, the world and all its inconstant creatures.

One day, however, during a period of testing, no sooner had I switched on the machine than a very old man materialised in the cabin, completely naked and staring at me in terror. I tried to speak to him, but at the first word he dropped dead. With total horror, I recognised myself in his withered face. And with an even more devastating shiver, I thought I understood: this was myself, returned from the future. On the spot I renounced all interest in this machine, and instantly abandoned it and the laboratory where I'd created it.

But human curiosity has been an irresistibly arousing thing since Pandora's time. So one day, as though in a trance, I found myself in front of the old laboratory and I glanced inside through the half-open door and saw eight corpses on the floor. Eight versions of myself, crumpled to the ground, informing me that doubtless others would follow. I tried time and again to destroy the laboratory and that infernal machine, but some strange force impeded me. Who knows? Perhaps it's written in my destiny that one day an irresistible impulse will drag me inside that machine to travel into my past, where I will understand that what awaits me is Death.

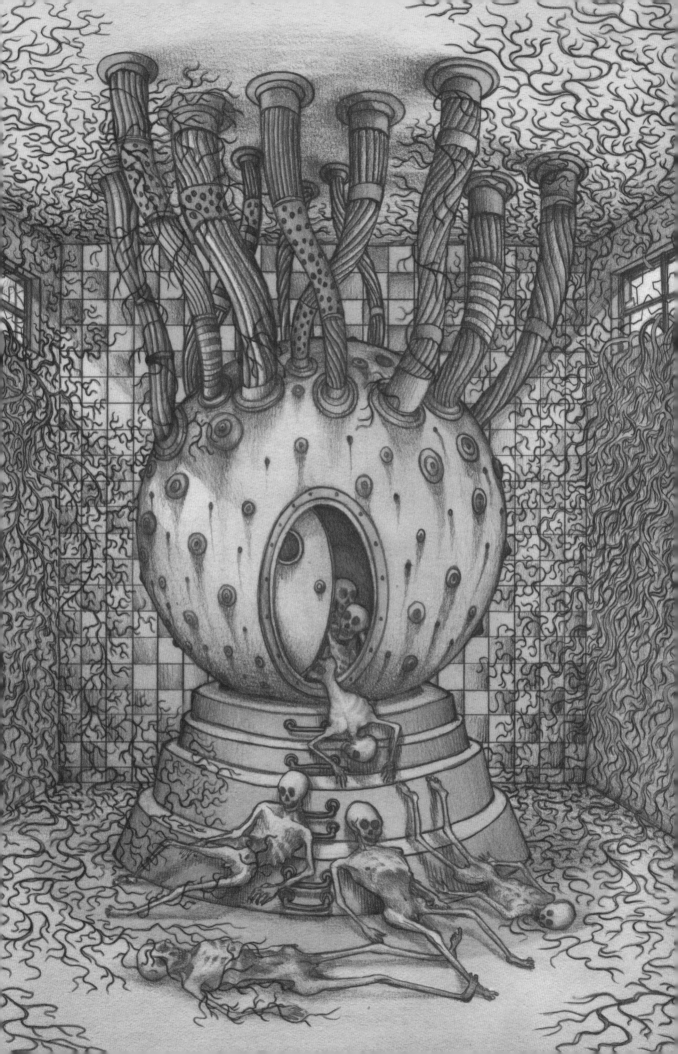

The Insects.

My garden is also home to certain small insects composed of two incomplete beings. One is little more than an unattached head, with nerve terminals resembling roots or shoots, and the other is precisely complementary, with no head, and a cavity where its central nervous system should be, filled with little perforations evidently destined to receive the head's dangling shoots.

The heads are the stamens which make up the androecium of the flowers of Magnolia pluricefala, *a plant which grows on the hills in my garden. In the months of August and September, these little heads detach from the flowers and float for days, transported by the wind.*

The bodies, on the other hand, are a distinctly unusual species of two-legged pupae of a butterfly called Spialia sertorius, *which after being abandoned by their mothers do not die, but become aware of their singularity and begin to follow the flow of the rivers, in search of the ocean.*

It would seem that both these components possess some kind of ancestral memory which draws them to meet each other on the 23rd of September every year on the coastline of the Solaris Ocean. Here — beginning at dusk and lasting all night — the heads float down from the sky, fluttering lightly like the winged seeds of the maple, while on the ground the countless pupae jump up and down, eager to receive their random partners. That night, hundreds of thousands couple together.

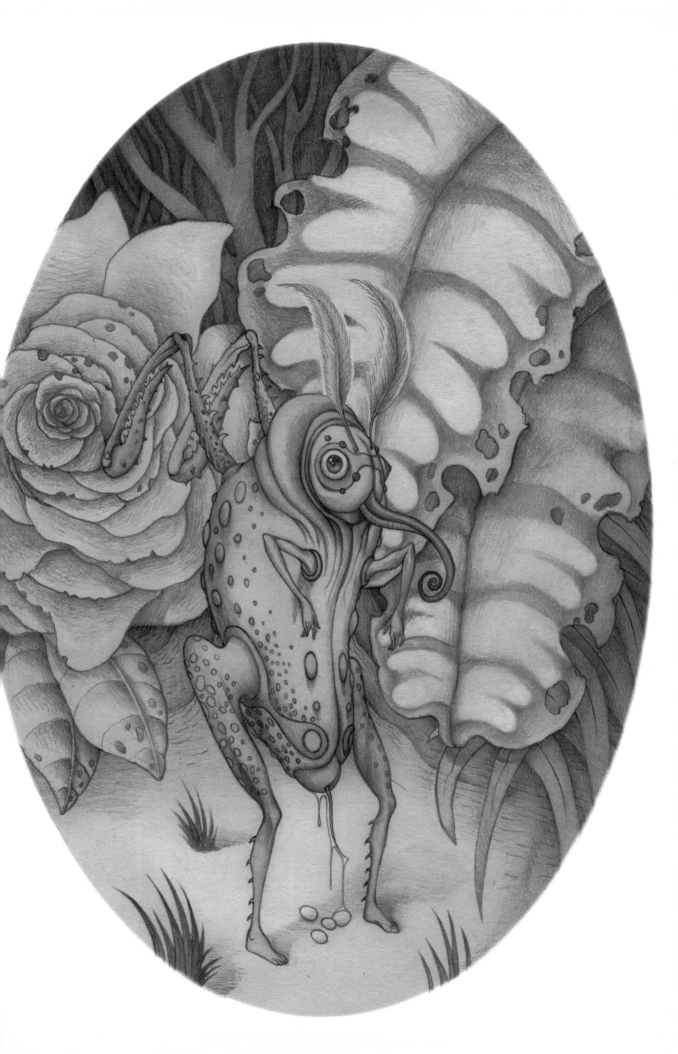

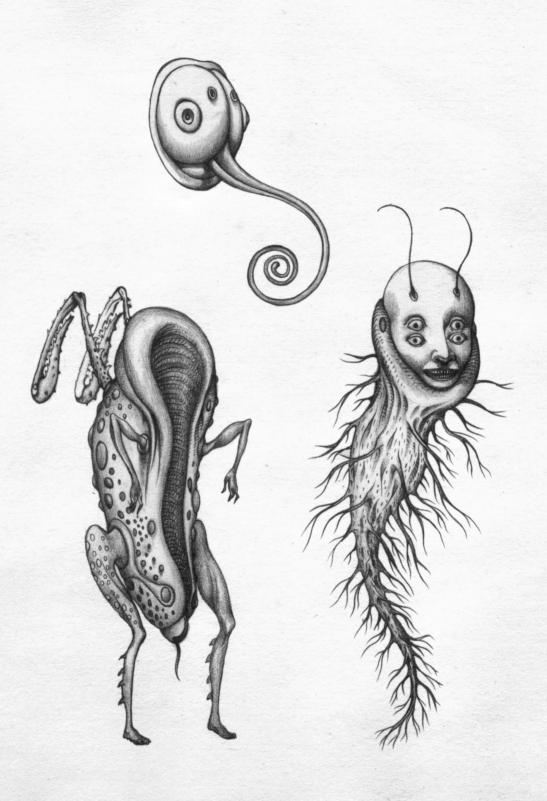

The Demiurge.

Distinctly millennial in appearance, he participated in the cosmogenic creation of suns and planets, a witness to and artifice of the transformation of the primordial energy soup into time flux and embryonic cosmic dust.

Over the course of the centuries, his head has served as a melting pot for nations, patiently molding concepts and blind material into top quality functioning creatures.

More recently his main hobby consists of churning out populations of homunculi which he feeds with his own bodily fluids.

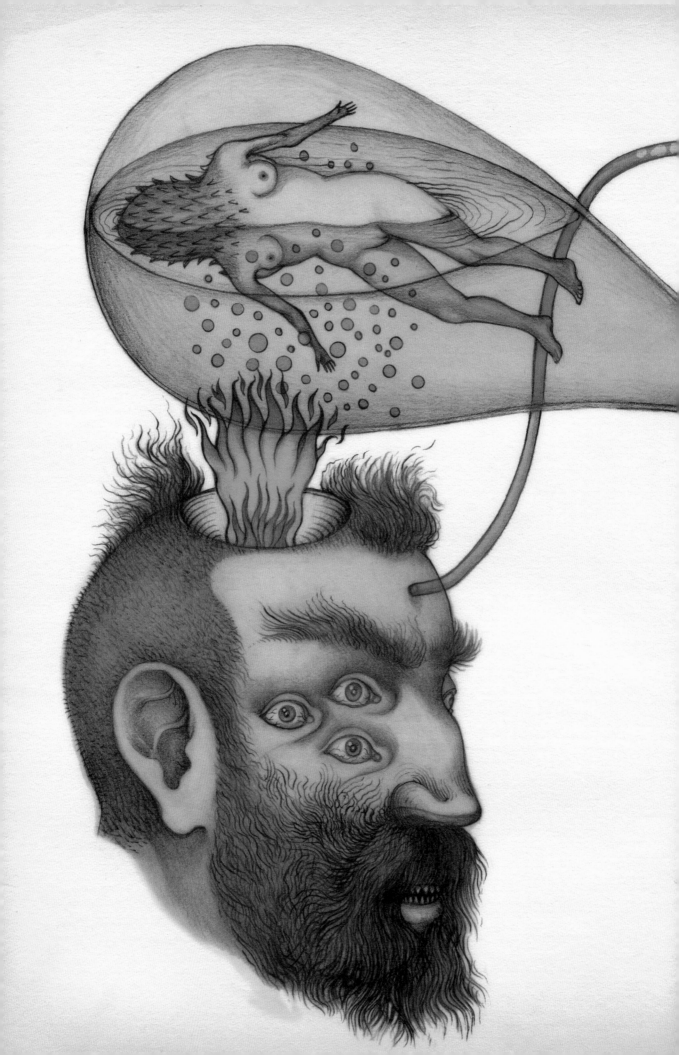

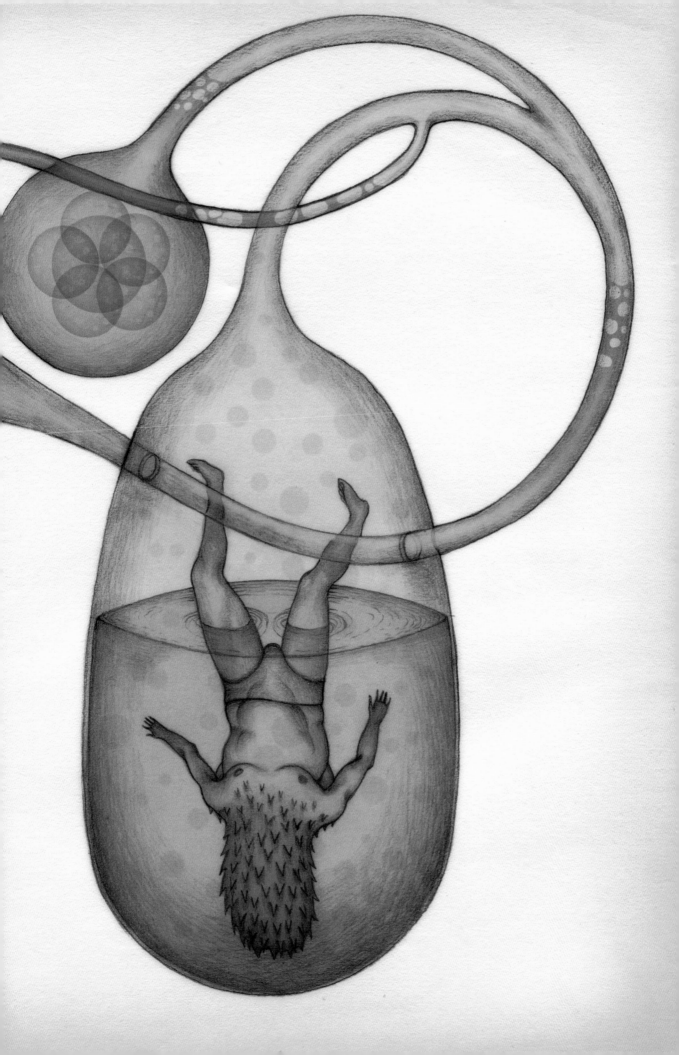

The Mandrake.

As tradition would have it, this creature was born in the shadow of a gallows, from the agonised sperm of some unfortunate victim of the executioner.

A scream marked the beginning of the vagabond life of this uprooted walking plant. Over time, the original scream was transformed into a sweet melody, capable of attracting the attention of those searching for it among the sounds of the forest undergrowth.

But the mandrake has learnt to hold back its song because, as everyone knows, the broth made from boiling its flesh (which has an intense purplish colour and an indescribable flavour of violets) helps to purify human blood of toxic humours — a fact which has generated widespread demand and intense hunting activity.

So nowadays the mandrake grows up voicelessly, in constant terror that at any moment, without even intending to, it might abandon itself to the vocal joys of its song.

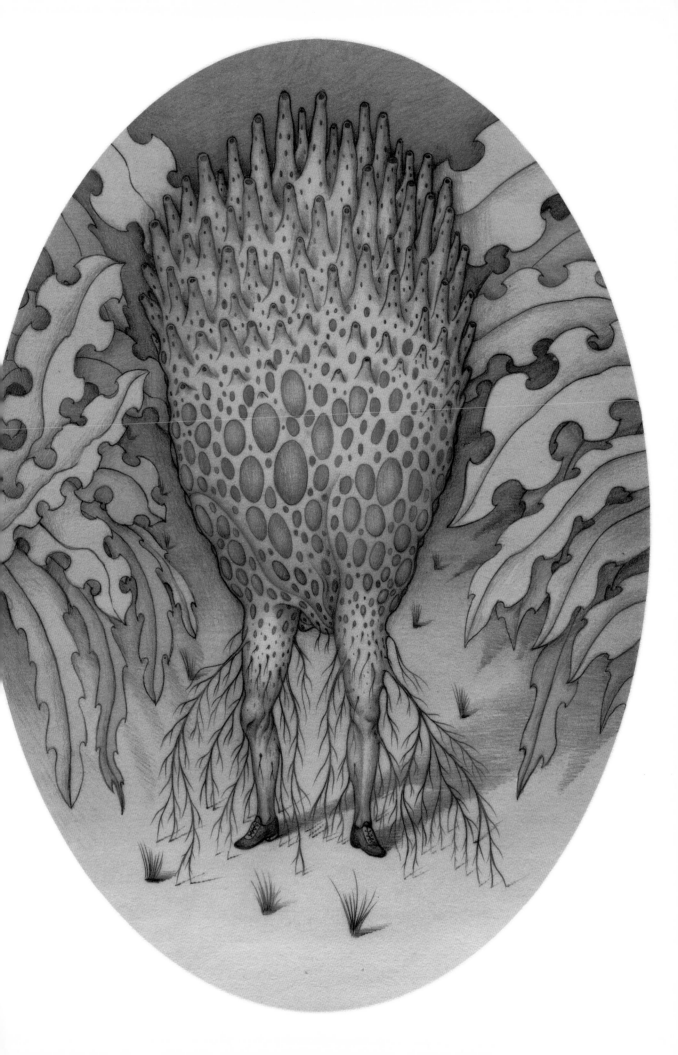

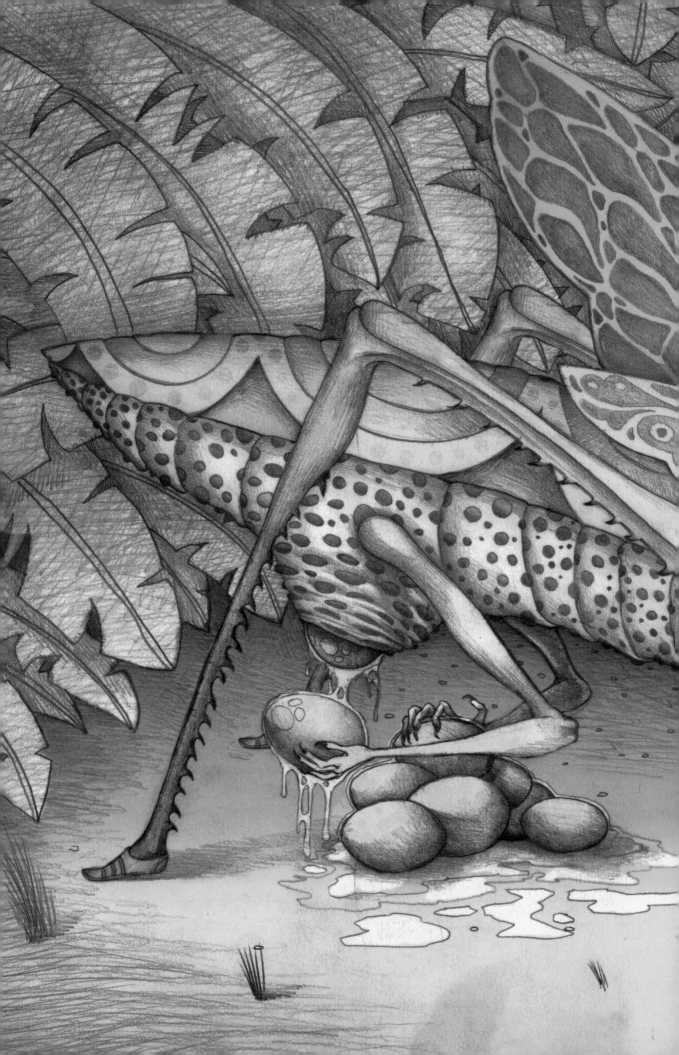

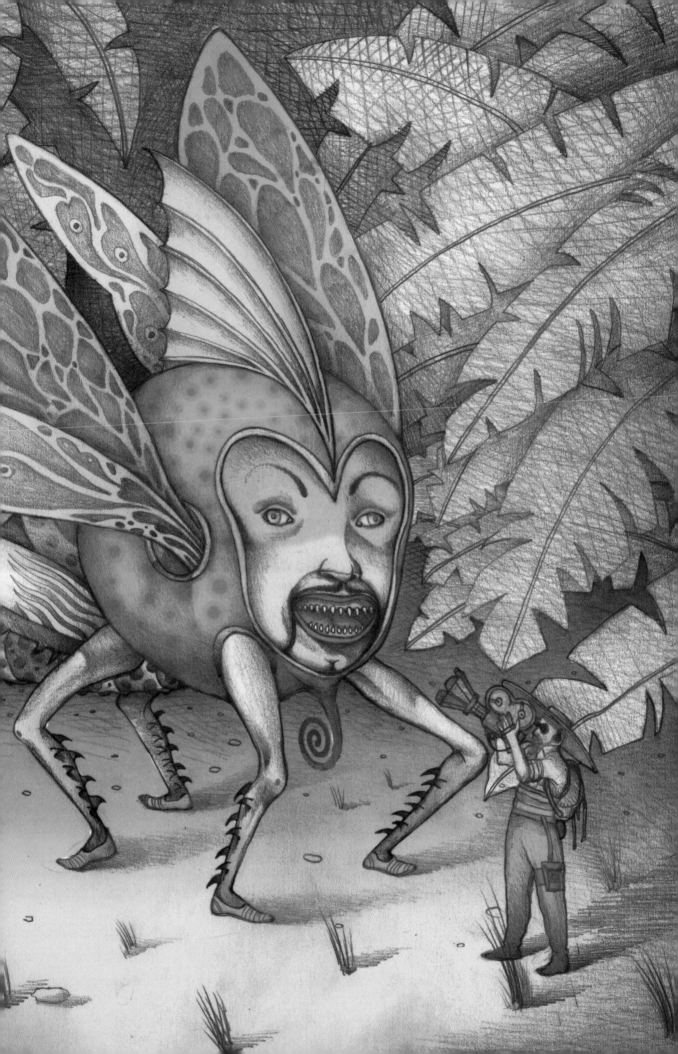

The Alebrijes.

Alebrijes are born from, grow up in and feed on people's dreams. An average dreamer needs roughly a year to incubate a medium-sized alebrije in their mind. One peculiarity of these dreams is that they are sequential: each one begins where the previous one ended. During the formative process, periods of wakefulness are brief and are basically devoted to hydration and the consumption of narcotic substances, which facilitate the dreamer's activity. The elaboration of these monsters is based on a system of "solidified imagination", proceeding fibre by fibre, membrane by membrane, muscle by muscle and bone by bone. Initially, they appear as translucent immaterial skeletal ghosts, but as the months pass and new dreamed fragments are added, the creature develops and finally the fateful moment arrives when, in the middle of the night, the alebrije leaps out fully formed from the dreamer's mouth in a spurt of amber-coloured ectoplasmic substance. Their consistency can vary greatly: some are colloidal, others solid, or earthy, or spectral or flaming. This all depends on the dreamer's spiritual temperature: alebrijes created from serene and harmonious dreams possess exquisite colours, shapes and behaviour, often singing with a beautiful voice, whereas those born from nightmares are sinister in appearance and can be dangerous.

The wrestler Lorenzo, nicknamed The Incendiary.

A highly singular character, who for many years practised the noble sport of "freestyle mutant wrestling". This sport could certainly be described as novel, especially as it is reserved for competitors gifted with different abilities, all of them rigorously abnormal. Some of them boast evident corporal mutations such as additional limbs, or limbs modified by technology, others possess superhuman strength, or thermal, levitational or psychic powers, and so on. To put it another way, they are all strongly influenced by post-humanism. Lorenzo's combat technique was known as "incinerative destruction", or alternatively "the fire bear", the latter a suggestive term for a method which consisted of hugging his opponents with his arms and legs and squeezing tightly (like a bear) and then creating a fire-burst with his body which would instantly reduce anything within a range of five metres to ashes. After winning the Universal Mutant Federation Championship and receiving the highest honours from the World Post-Humanist Association, Lorenzo retired, in order to rest his unstable humanity. For a while he then worked freelance, as a mercenary, accepting commissions which usually turned out to be extremely criminal, but he now leads a pacific life in my garden, disturbed only by occasional vindictive assaults from his victims' or his dead adversaries' relations.

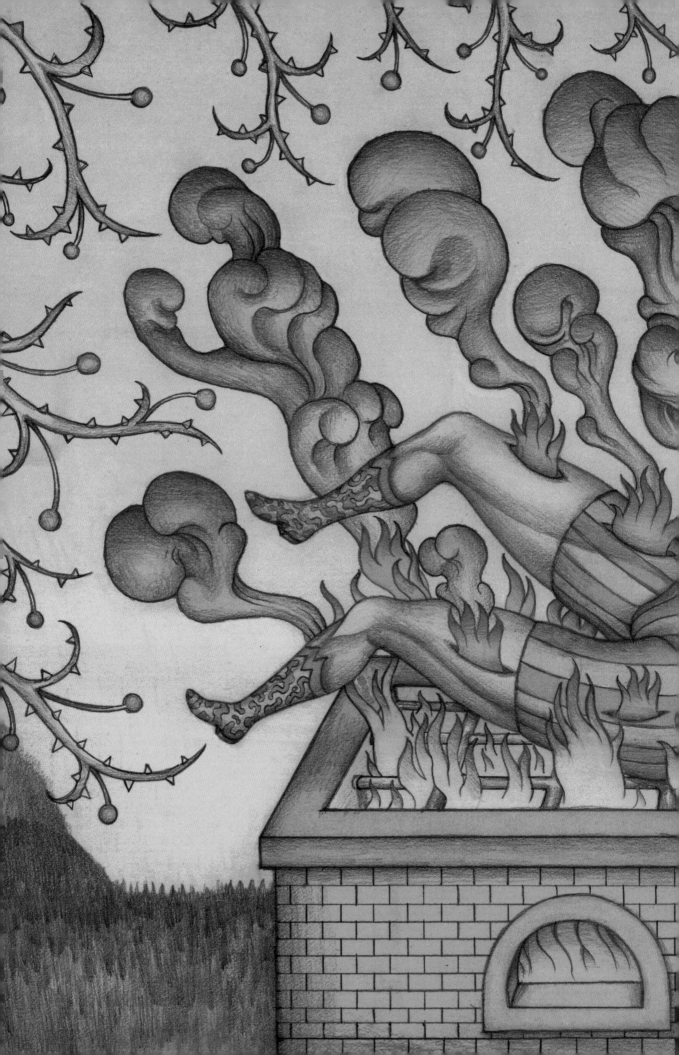

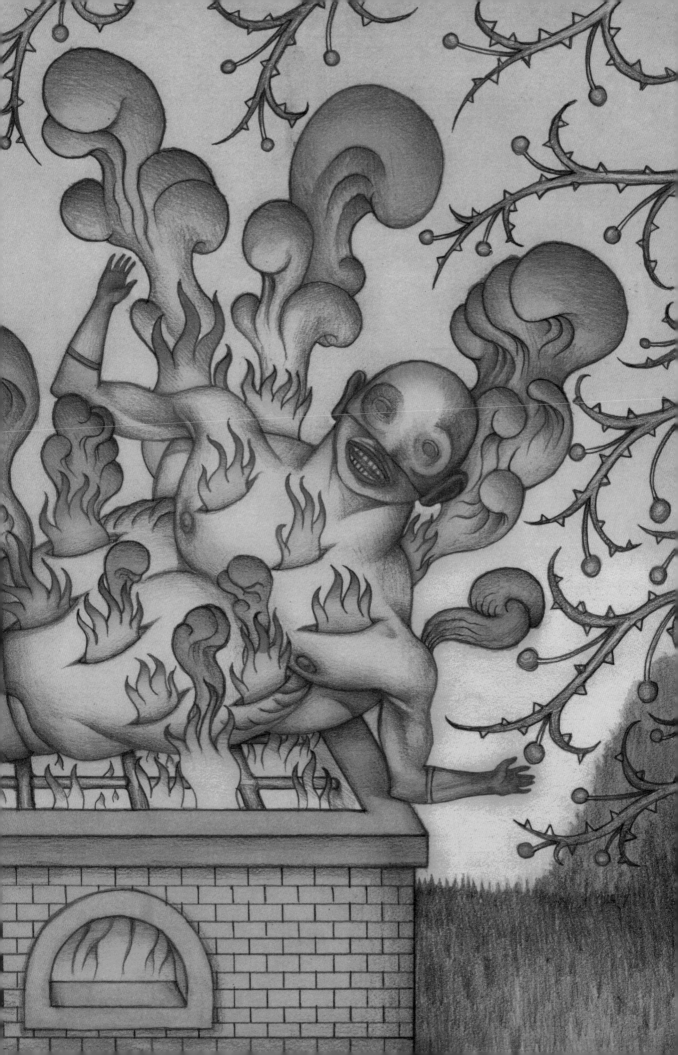

The Mimoid.

My garden contains an ocean called Solaris. Over time I have discovered that this is an alien ocean, which must have reached our planet as a comet which, on impact with the atmosphere, found that its ice-like soul soon liquefied.
Solaris is aware of itself. It tries to communicate using solid discursive strategies, in the real sense of the word. For example, along its shores one frequently encounters the ghosts of dead family members, spectral figures created by the ocean in order to be able to see the world through human eyes, to approach living people and – before disappearing – asking them complex questions like "What do you know about the finiteness of life?" or "In which kingdom would you situate the nature of desire?".
But Solaris also experiments with other methods of communication. One of these is the mimoid. This is an extraordinary phenomenon which I would dare to classify as a form of language, and which can assume the strangest consistencies and appearances. Some mimoids have a calcareous structure, others consist of a colloidal substance, or of living jelly-like water, or alternatively appear like gigantic swabs of candyfloss. Their duration is also highly variable. Sometimes minutes pass which feel like millennia, other times you blink and find the moment has already culminated and dissolved forever. In general the mimoids present themselves in the form of huge skeletons of primordial beings whose continuous kaleidoscopic metamorphoses represent – as though on the stage of a theatre – something which we can only guess at.
To this day, I continue to scrutinise the ocean in search of answers, like a child gazing at the night sky.

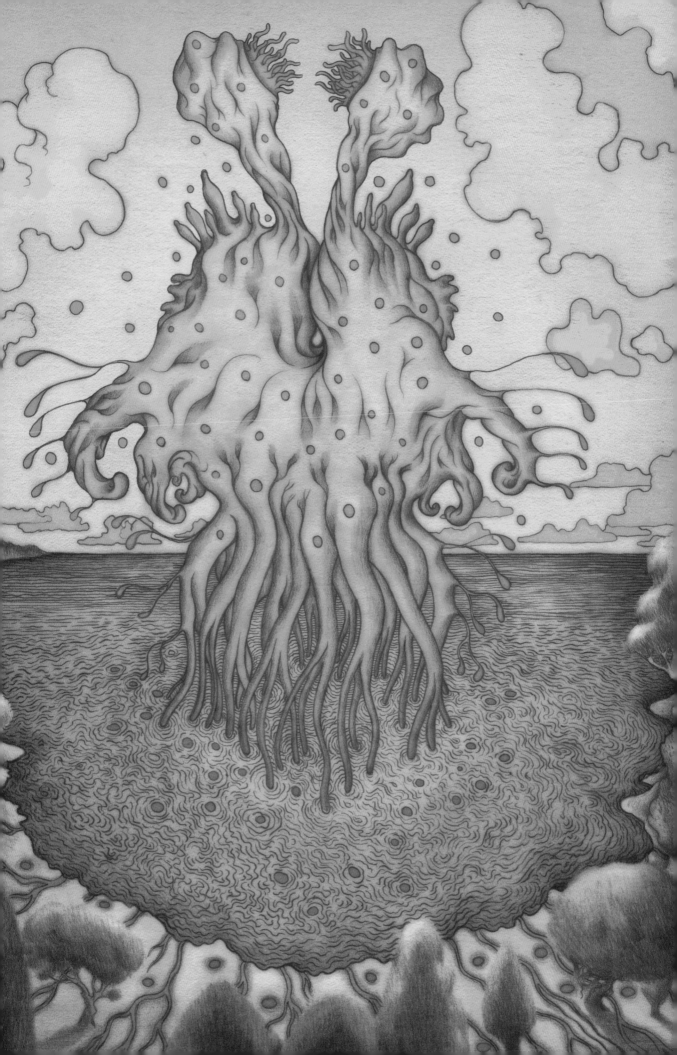

The Giant Jellyfish.

They swim in the oceanic depths of my garden. They connect the submarine communities with the surface and at the same time serve as messengers and means of transport for both living beings and merchandise, swaying between one submerged city and another, balancing their cargo on their backs or inside their enormous stomachs.
Recently their services have been increasingly requested on account of the increased traffic of "oceanic transhumans": these are individuals who, inspired by a custom popular among New Testament Christians, try to reproduce in a controlled and ritualistic form the experience and suffering of Jonah swallowed by the Leviathan.

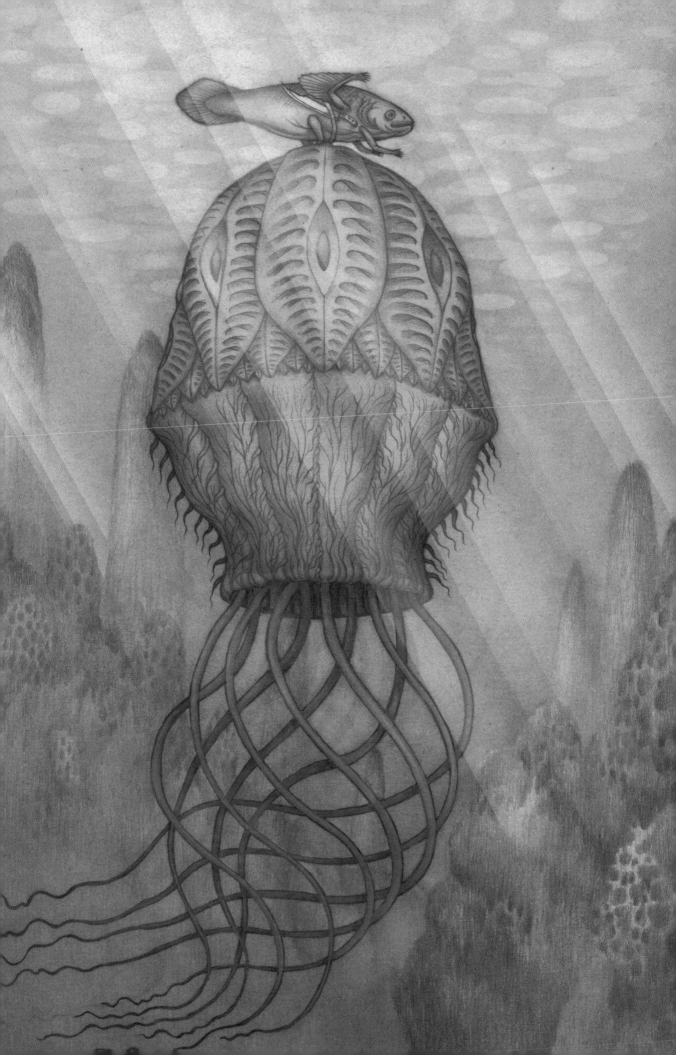

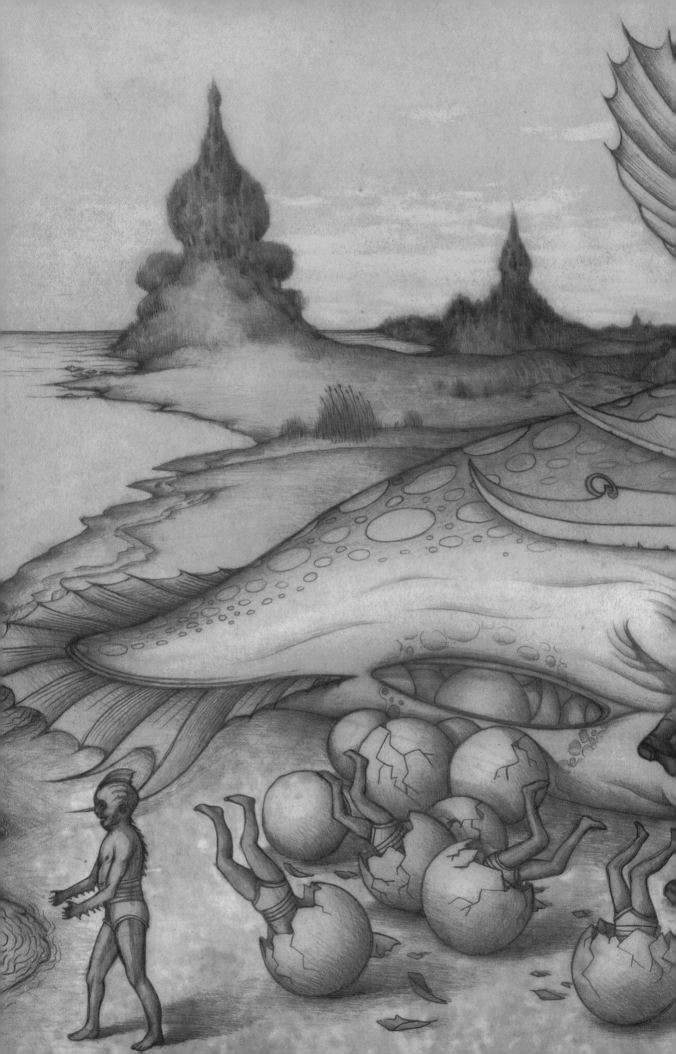

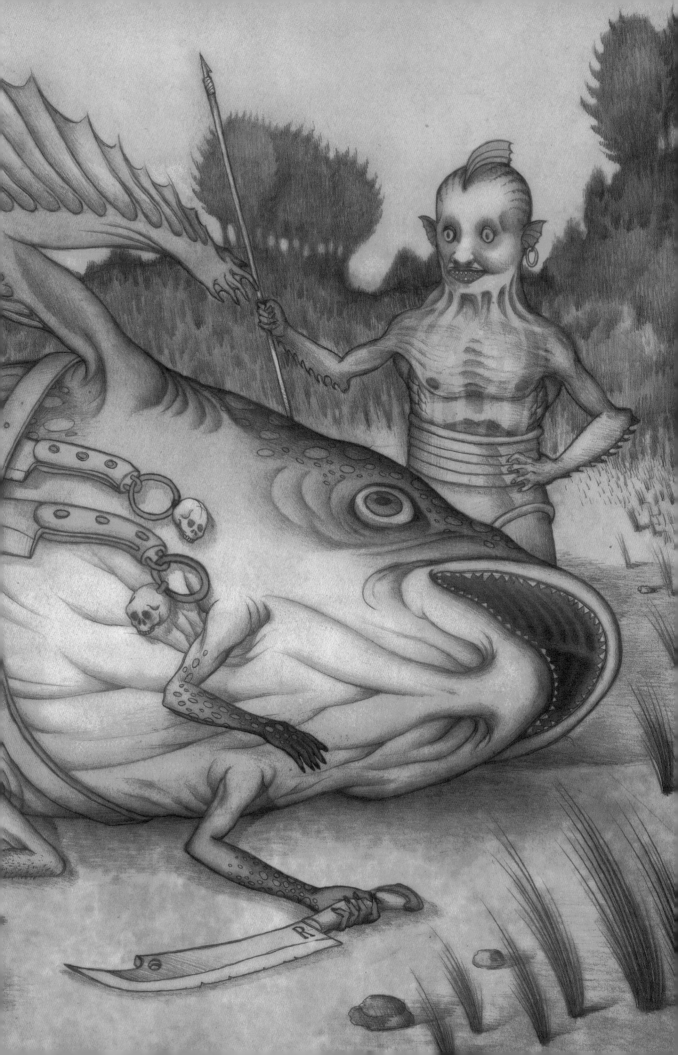

The Fishassassins.

Every year, on the shores of my garden, the fishassassins lay their eggs.
A century ago, during the War of the Nereids, these creatures played an active role in the devastating conflict for the conquest of maritime ascendency between the race of Tritons and human colonisers. On that occasion, the Tritons employed whole mercenary legions of these fishes. They were ferocious in battle, and were recognisable by their daggers decorated with the skulls of their victims. They played a crucial role in the sieges of the submarine fortresses built by the humans, and also in the carnage of the battles of the abyssal trenches. Following the definitive victory of the Tritons, after the Massacre of the Grand Aleutian Trench, the humans surrendered and were expelled from the great ocean. The fishassassins were then used to flush out the last pockets of enemy resistance and finally, after the end of hostilities, the legions were dissolved and their members assigned to other duties. Today, for example, they perform as incubators in the last phases of maturation of Triton eggs, and as such, they participate every year in the journey to Cephalo Island for the mass deposition of the eggs. So far, no human has ever managed to witness this extraordinary event.

The Behemoth.

In ancient times it was believed that the earth was perched on top of a diamond, that the diamond was cradled in the hand of an angel, the angel was standing on an elephant, the elephant on a turtle, the turtle on the Behemoth and the Behemoth on nothing less than the luminous and eternal consciousness of God. A Behemoth actually floats in the sky above my garden. It's a young Behemoth. Unlike the older ones, which transport whole worlds on their backs, mine simply has one mountain chain with a sprinkling of volcanos. Its soporific whale-like song and its enormously slow progress across the sky (a single transit can take several years) stain the surrounding landscape with a melancholy bluish atmosphere. Anyone who finds themselves in its shadow feels that time has become far more dense, movements far more relaxing and food a great deal saltier.

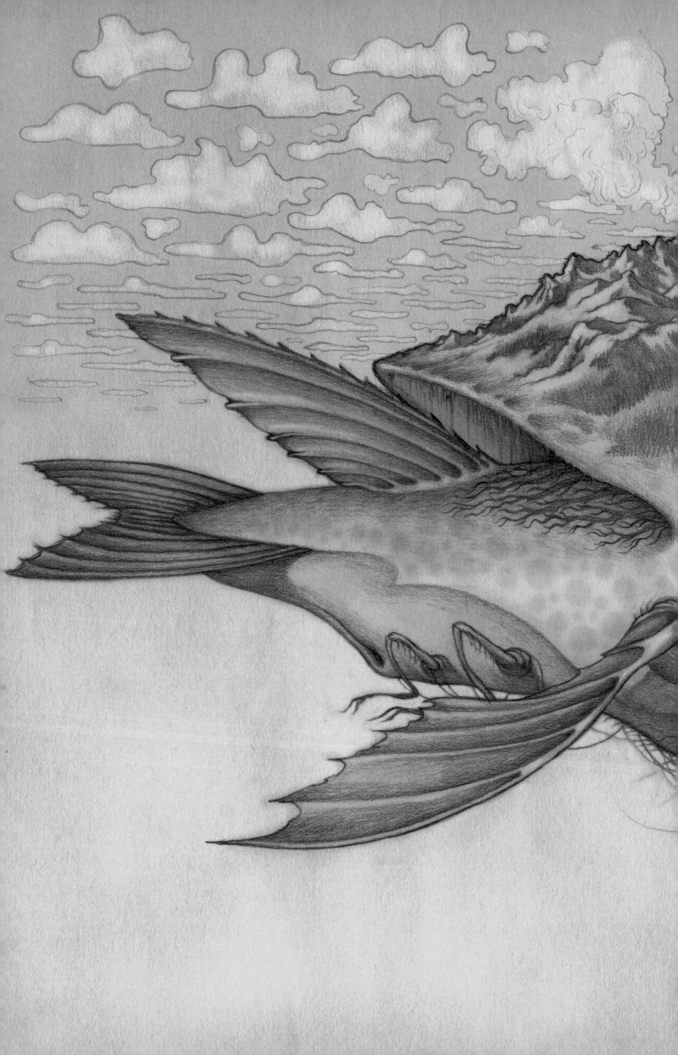

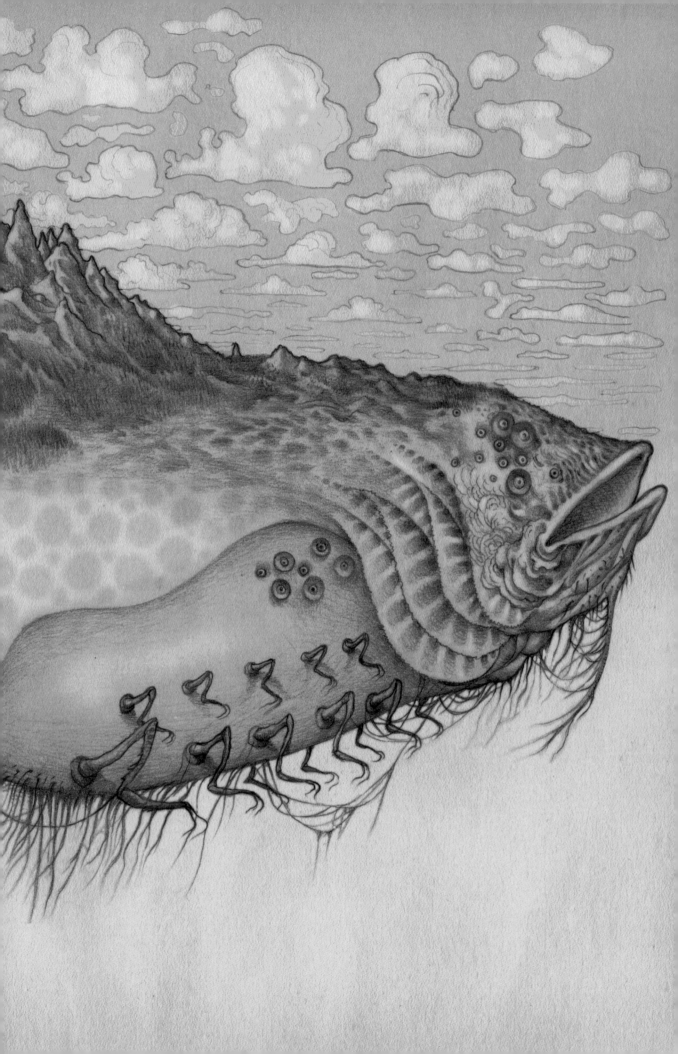

Cephalo Island.

In ancient times it was believed that the earth we live on was made up of the dead bodies of primordial beings: Titans devoid of language but yet immortal, with telluric powers but long defeated by the civilising heroes. Mountain chains were considered their spines, lakes their empty eye-cavities, and rivers their ancient veins running through their landscaped bodies. Cephalo Island still conserves clear signs of this arcane morphology: it is undoubtedly made up of the mortal remains of a primitive marine Titan. There are two cities on top of his head, whose inhabitants dedicate their lives to the rigid discipline of nautical cartography. Nevertheless, one should note (perhaps due to their position, so close to the absent brain of the old Titan) their maps are not reliable: the territories they map invariably tend to assume the shapes of imaginary hybrid beasts. This curious distortion must be caused by some still-resonating ancient thought of the colossus, floating as a rarefied vapour inside the hollow geography of its body.

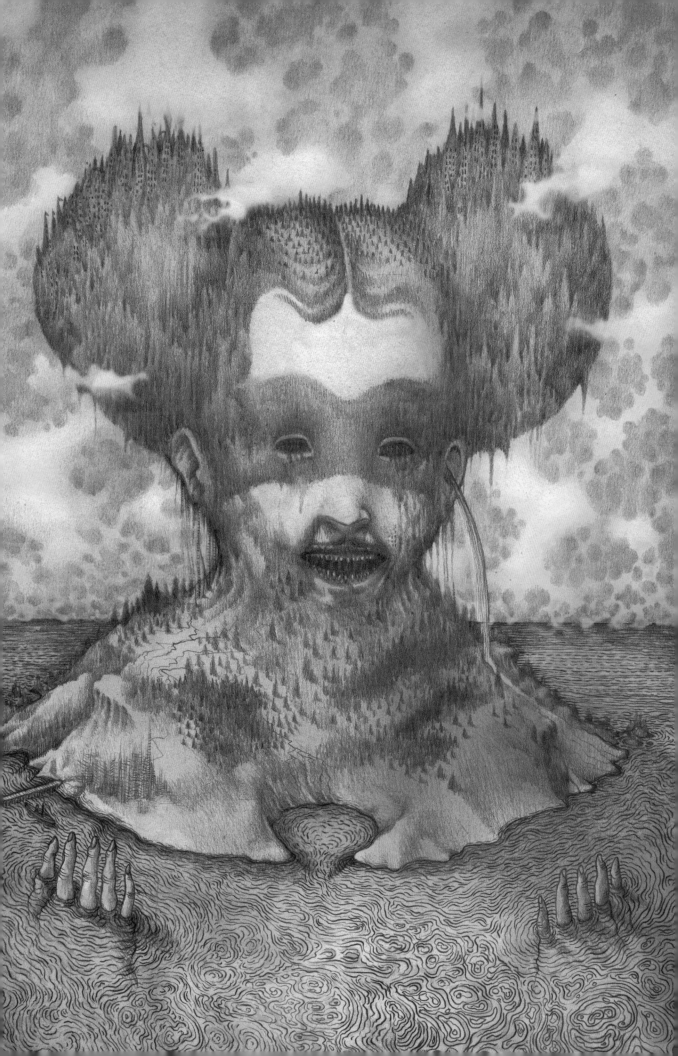

Austral Aurelia.

Immense levitating cities grow in the sky above my garden. Many centuries ago, an all-telepathic tribe settled in these parts, and before long they managed to fuse their own consciousness with that of the plants. With the passing of the generations, the tribe began to modify the surrounding landscape by telepathically transforming trees, shrubs and creepers. And thus this shared collective consciousness ended by assuming the features of an entire landscape. The enormous Aurelia was formed more recently, and began its levitation only a few hundred years ago, drawing energy from the sun for its necessary photosynthesis and hydrating itself from the huge clouds that move through it. The Aurelians — produced by their own sophisticated techniques of extra-sensorial communication — are a prosperous and pacific people, dedicated to meditation and philosophy. Today their city is a spiritual centre and place of pilgrimage for women, men and whole populations in search of truth, but it also welcomes simply curious visitors, and tired emissaries from distant planets who hope to find among the Aurelians the answers which their own rigid metaphysics would never dare to formulate.

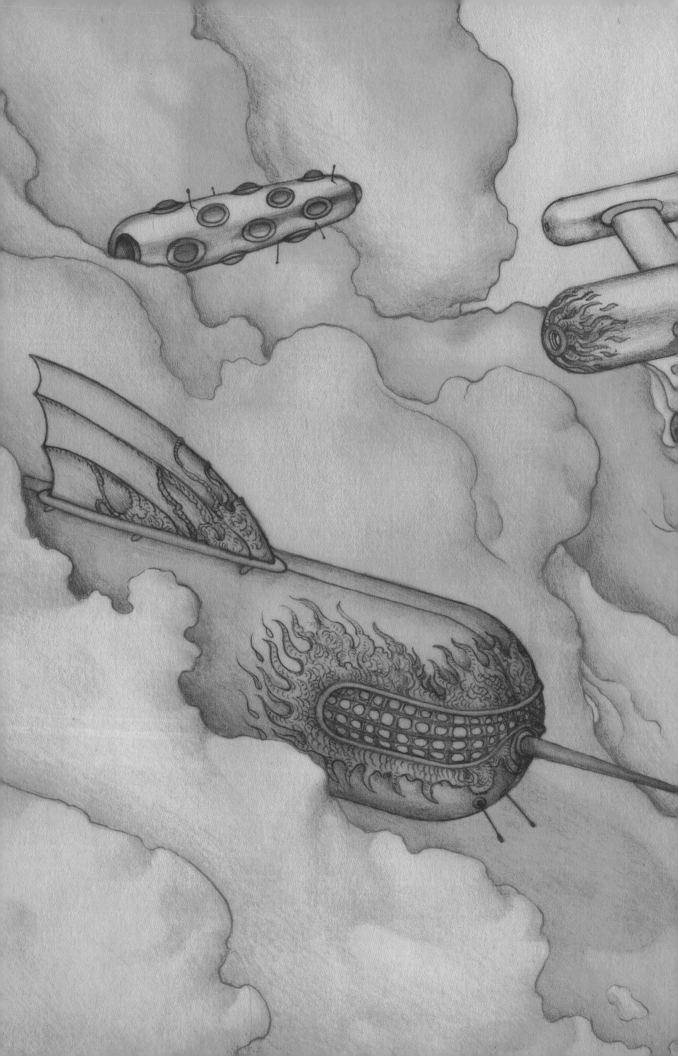

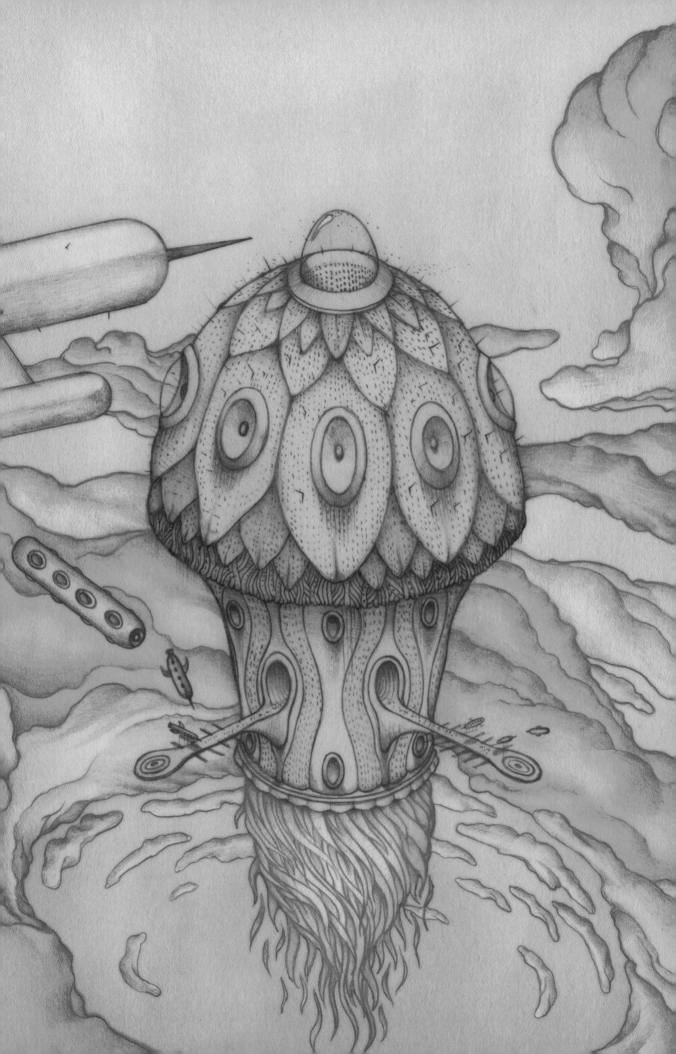

The Cosmonauts.

The sky above my garden often witnesses the passage of golden spaceships piloted by cosmic travellers. Explorers of celestial territories, during their voyages they fly above planets scattered with cities of gold and crystal which know no darkness, peopled by beings formed of differing plasmas and dancing spirits. This ancient race, distinguished by its incredible longevity, has witnessed countless supernovas explode and howl, disseminating fertile soma and gamma rays across the vast and sterile shadows of the universe. Wandering among dilapidated suns emitting cold weak light and reddening dwarfs saluting the eternal night before they die, they have accompanied the life and death of nebulae that generate the galaxies and of voracious black holes starving for yet more light to devour.
Immortal witnesses, drops which will never mingle with the ocean.

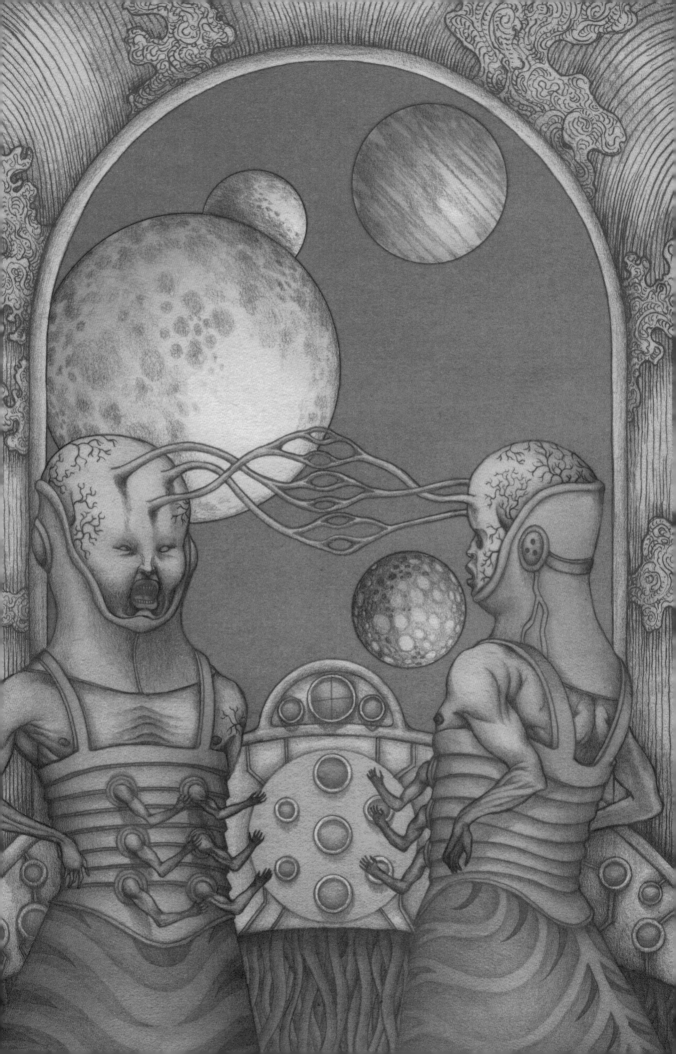

The Nebulae.

The sky above my garden holds countless millions of planets. My favourite is called Atanasius Uterinus. A uterine star, it contains a small sun and diffuses a pleasant tepid warmth through underground prairies and interminable caverns which are home to populations and cities hidden from other suns.
The sky also contains immense nebulae gravid with cosmic dust and primordial soma, generators of untold worlds, constructors, demiurges of infinitely faraway realities and times.

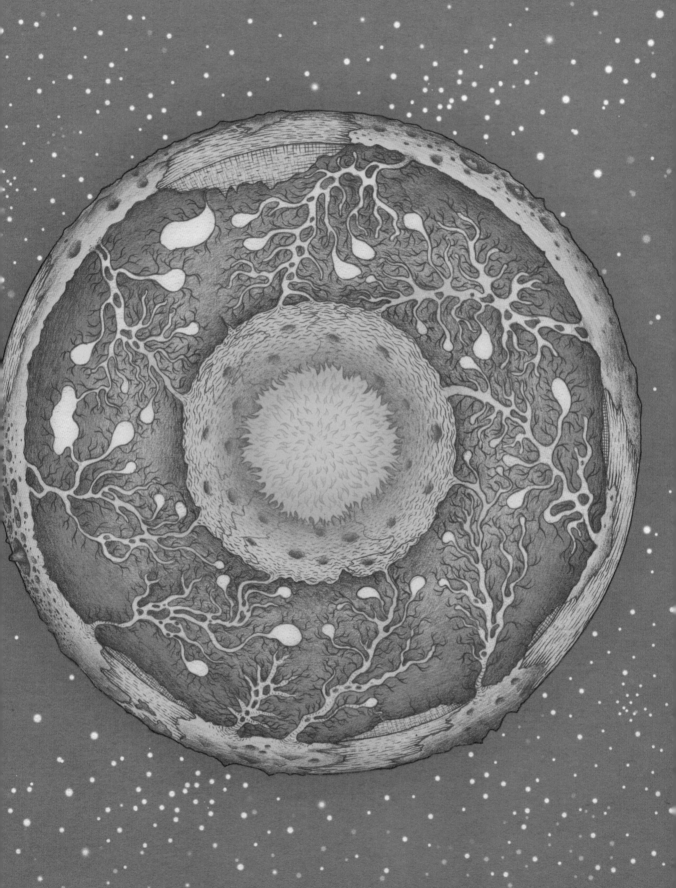

I don't know the boundaries of my garden. I find them inconceivable. In the end I have come to the conclusion that they don't exist. This explains why I can't see them. And another thing: wherever I find myself in my garden, I always know myself to be at its centre.

My garden palpitates, stretches and breathes like a living organism. For a while now, I have realised that I don't live in this garden, it lives in me... and that quite probably it is a concrete manifestation of my imagination.

Infinite infinites, specular union of insides and outsides, I have recently discovered that my garden is connected with an incalculable number of other gardens.

Situated in other places.

And in other times.

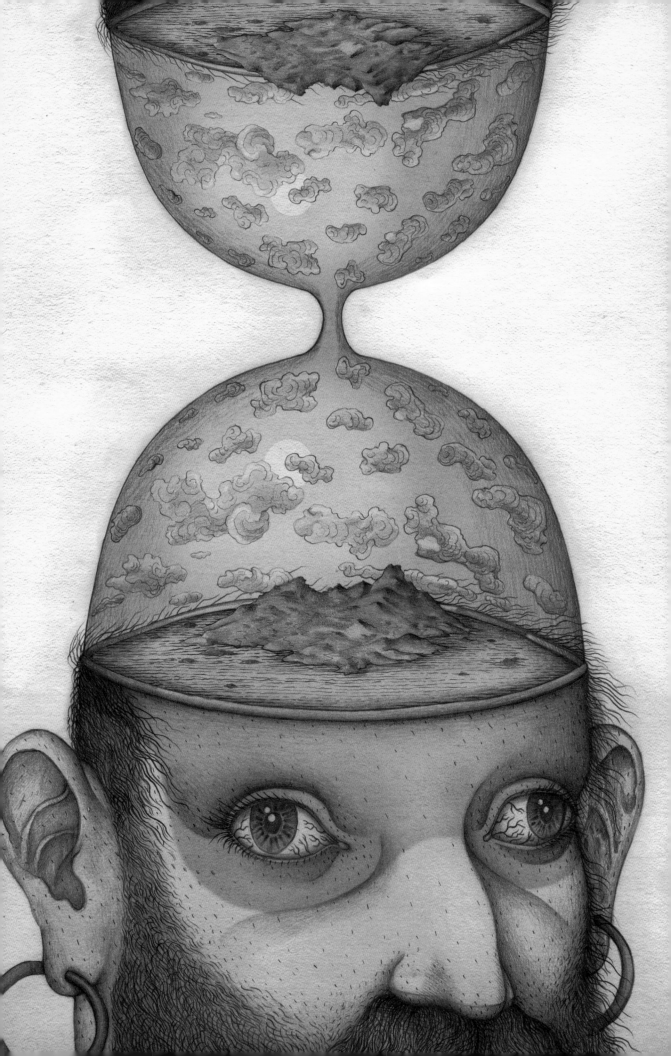

Self-portrait

During my childhood, in the port of Talcahuano in Chile, I used to love drawing in the kitchen of my grandfather Francisco "Pancho" during the afternoons, when the sun flooded his house and he made me bread and butter and hot milk, with pieces of melted cheese which I ate with a spoon. The things I loved drawing most were warships, sailing ships of every kind, entirely invented ships and, of course, my grandfather, of whom I drew countless portraits, while above us the seagulls dropped cholgas[1] and clams onto the roof of the house, so that they could eat from the broken shells.

Every year, in November, the port-town celebrated the anniversary of its founding with a carnival. I remember that one evening, when I was still little, I watched as the murga de los merluzos[2] marched past in front of the house: this was a phantasmagorical parade of people dressed up as impossible sea creatures – as cochayuyo[3] seaweed, cholgas, choros[4], clams, hakes, jaibas[5], congrios[6], octopuses, horse mackerels – all dancing in rhythm to the percussion and the hundreds of deafening boatswain's calls. Their costumes glittered like Christmas trees, putting such a spell of enchantment on me that at a certain point, without even realising it, I started following them. Before long I realised that I was in a part of town I didn't know, it was late, and the band was getting further and further away along the road. I found myself alone in the dark. Terrified, I started searching for the road home... and luckily, after turning a few corners, there was my mother, extremely worried.

Like every good Catholic family, our home was crammed with items of religious art. My grandmother Flavia had a little altar featuring a statue of the Virgin of Carmel, the patron saint of Chile, and she was always surrounded by a crowd of smaller holy paintings and statues. One day, while pulling off a pullover in a rush, I bumped into a statue of Saint Judas Thaddaeus, which fell to the ground and shattered. My mother reassembled it, but instead of using glue she wrapped it tightly in cloth like a little mummy, with only its face peeping out at the top, and then laid it inside a wooden drawer. To this day, when I open that drawer searching for something or other, I find myself looking into the eyes of Saint Judas, which show no trace either of rebuke or forgiveness.

Years later, at university, I learned engraving techniques, and this allowed me to develop my drawing ability and carry out my first series of graphic works and books of engravings. My woodcuts, etchings and lithographs in limited editions treated subjects like the origins of the Golem, the feverish dreams of a child maddened by love, chronicles of prodigious events, fantastical anatomy, and so on.

Subsequently, during my postgraduate studies in Mexico I began illustrating books for various publishers, thus reaching a wider public and also enriching my output with various new contents.

Today I teach drawing techniques and, together with a group of friends, take pleasure in publishing the kind of books that I would have always loved to hold in my hands.

Claudio

[1] *Cholga: Magellan mussel* | [2] *Murga de los merluzos: a wordplay between the Spanish* merluzo, *"fool", and* merluza, *"hake". Murga means "band"* | [3] *Cochayuyo: edible seaweed from South America, from the Quechuan* qhucha yuyu, *"sea plant"* | [4] *Choro: Chilean mussel* | [5] *Jaiba: king crab* | [6] *Congrio: conger*

A JOURNEY IN THE PHANTASMAGORICAL GARDEN OF APPARITIO ALBINUS

© Claudio Andrés Salvador Francisco Romo Torres

First Published in the United States of America, 2017
by Gingko Press, Inc. - 1321 Fifth Street, Berkeley, CA 94710, USA
www.gingkopress.com

Under License from #logosedizioni

Originally Published in Italy by © #logosedizioni, 2016

Translation: David Haughton
Layout: Alessio Zanero

ISBN: 978-1-58423-693-1

Printed in China by ❦ Book Partners China Ltd

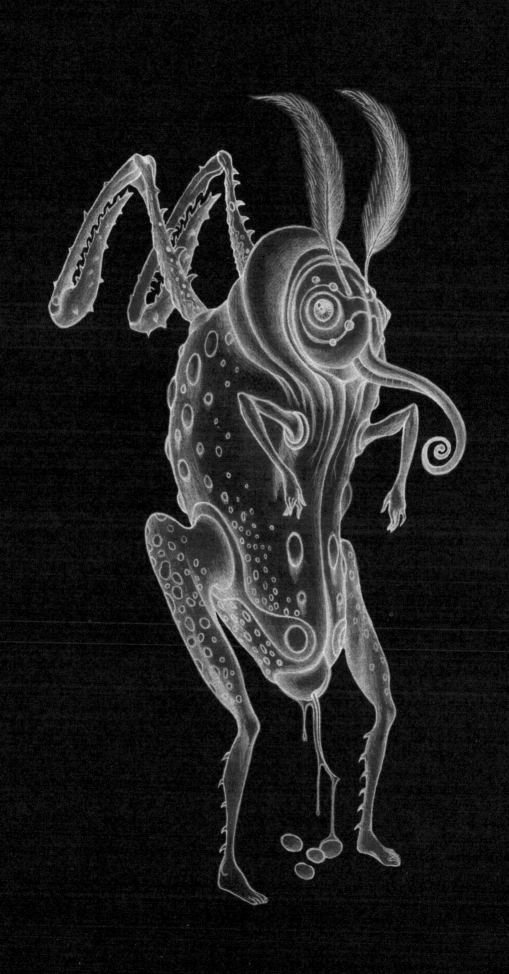